Arcimboldo

THE LIFE AND WORKS OF

ARCIMBOLDO

Diana Craig

A Compilation of Works from the

BRIDGEMAN ART LIBRARY

PARRAGON

The Life and Works of Giuseppe Arcimboldo

This edition first published in Great Britain in 1996 by
Parragon Book Service Limited
Units 13-17 Avonbridge Industrial Estate
Atlantic Road
Avonmouth
Bristol BS11 9QD

ISBN 0-7525-1131-9

Printed in Italy

Editors:	Barbara Horn, Alexa Stace, Alison Stace, Tucker Slingsby Ltd and Jennifer Warner
Designers:	Robert Mathias • Pedro Prá-Lopez, Kingfisher Design Services
Typesetting/DTP:	Frances Prá-Lopez, Kingfisher Design Services
Picture Research:	Kathy Lockley

The publishers would like to thank Joanna Hartley at the Bridgeman Art Library
for her invaluable help.

GIUSEPPE ARCIMBOLDO 1527-1593

Arcimboldo

The story of Arcimboldo is far from the stereotype of the tortured artist, suffering for his art. In fact, Arcimboldo seems to have lived a life of comparative ease, celebrated as an artist in his own time, well-liked as a man, and enjoying the patronage and protection of a succession of powerful and wealthy emperors.

Giuseppe Arcimboldo was born in 1527, the son of Chiara Parisi and Biagio Arcimboldo, a painter employed at Milan Cathedral. Interestingly, this was also the year of the birth of Maximilian II, who would later be Arcimboldo's patron. There is some confusion about the exact spelling of the family's surname. Biagio sometimes spelt it Arcimbaldo or Arcimbaldi, while Giuseppe sometimes used Arcimboldus and varied the spelling of his first name to Josephus, Joseph or Josepho.

The family into which the young Giuseppe was born had influential forbears. His great-great-grandfather, Guido Antonio, was Archbishop of Milan from 1489, while his great uncle, Gianangelo Arcimboldo, held the same office from 1550 to 1555. As a result, Arcimboldo's youth was spent in a world of art and culture. At the home of his great uncle, he would have met artists, scholars, writers and leading humanist thinkers, and would also have been familiar with the work of German artists working at Milan Cathedral or producing tapestries for the Medici family. Through the son of Bernadino Luini, he would also have seen the sketchbooks and notes of Leonardo da Vinci – Leonardo had bequeathed them to Luini, his pupil and a friend of Arcimboldo's father.

Arcimboldo began practising as an artist when he was 22 years old, working alongside his father Biagio, producing designs for stained-glass windows for Milan Cathedral. Some of the windows, depicting scenes from the life of St Catherine, still survive. Other early work includes highly decorative and sumptuous tapestry designs, which hint at the direction Arcimboldo's art would later take.

Four years later the young artist's life was to take the turn that would establish

him in a successful career for the rest of his working life. Arcimboldo was born in the days of the great artistic patrons – wealthy and powerful popes, monarchs and aristocrats – whose support and interest assured an artist of commissions and an income, and whose patronage facilitated some of the greatest masterpieces Western art has ever produced. The development of Arcimboldo's art, over more than a quarter of a century, is inextricably bound up with the interest shown in him by three rulers of the Hapsburg dynasty – without their hospitality, protection and influence, Arcimboldo's story would have been very different.

The seeds of the artist's good fortune were perhaps sown as far back as 1551, when Ferdinand, then Duke of Bohemia, passed through Milan and commissioned Arcimboldo to paint for him five coats of arms. Arcimboldo's work must have made a great impression on the Duke for, when he later succeeded his brother Charles V to become Ferdinand I, Holy Roman Emperor and ruler of the mighty Hapsburg Empire, he decided that he wanted Arcimboldo for his court painter. After repeated requests from the insistent monarch, Arcimboldo finally succumbed, and joined the court in Vienna in 1562.

It was at the Hapsburg court that influences from his earlier life, mingling with new impressions and experiences, came together in an artistic melting pot to produce the fantastic, imaginative creations for which Arcimboldo became famous. In the imperial art collection, he would have been introduced to the works of Dutch and German painters such as Bosch, Breughel, Cranach and Altdorfer, all highly detailed and often strange in their subject matter – quite unlike anything in Italian Renaissance art.

Having arrived at court at the age of thirty-five, Arcimboldo was to serve his new master for only another two years. In 1564, Ferdinand died, to be succeeded by his son, Maximilian II. Maximilian kept Arcimboldo on in his employ, paying him 20 guilders a month, with the occasional bonus – perhaps for a favourite painting – of an extra 100 guilders or so. It was during this time that Arcimboldo painted the first of his famous *Four Seasons* series. The concept behind these pictures made a huge impression, and marked the turning-point in his career.

Arcimboldo was clearly in great favour with Maximilian – the Emperor made a point of officially recognizing his illegitimate son, Benedict, and, before his death, gave the artist a final gift of 200 guilders. When Maximilian died in 1576,

his son took the throne, to become Emperor Rudolph II. Like his predecessors, he continued to employ Arcimboldo as painter to the court, now in Prague.

Perhaps as a refuge from the trials of rulership, Rudolph sought solace in the worlds of art and science. Scholars, astrologers, alchemists and mathematicians visited the court, which became a major cultural centre. Rudolph also turned his attention to the existing collection of curiosities and added to it enormously, even to the extent of employing agents to scour the world in search of new treasures. The collection – known as the *Wunderkammern*, 'the rooms of art and wonders' – increased in size and fame. Here, Arcimboldo could study at first hand those subjects he wished to include in his paintings – antiquities, *objets d'art*, strange and precious objects from the East or the New World, stuffed birds, fish, as well as exotic live animals.

The stimulating environment at Rudolph's court provided the rich soil in which Arcimboldo's work could reach its full flower. His work, however, was not restricted to the world of art. With his thirst for learning and understanding, Arcimboldo was architect, scientist, engineer, stage and costume designer as well as painter. In this, he was very much a man of his age, for the 16th-century mind did not impose the rigid divisions on human activity that we do now: an individual could be both artist and scientist at the same time.

In 1580, as a mark of favour, Rudolph conferred noble status on the Arcimboldo family. In 1587, after serving the Emperor for 11 years, Arcimboldo was finally allowed, after many requests, to return to Milan to spend his old age there. He did, however, agree to continue to work for the Emperor, even though he was no longer in his service. As a final gesture of thanks, Rudolph made him a gift of 1550 guilders.

In the register of deaths in Milan in 1593, the record states that Arcimboldo died on 11 July of that year, at the age of sixty-six. The cause of his death is unclear: he appears to have succumbed to one of the diseases of old age, not to the plague that was ravaging the city at the time.

The great fame that Arcimboldo had enjoyed during his lifetime soon waned after his death. In the two centuries that followed, he languished in obscurity, only to be 'discovered' again in the late 19th and 20th centuries, by the Surrealist Movement in particular.

Detail

▷ **Self-Portrait** c. 1575

Pen and blue wash on paper

THIS DRAWING, OUTLINED IN PEN and in-filled with blue wash applied with feather and brush, reveals a sensitive, thoughtful face. At the time Arcimboldo drew this self-portrait, he would have been about 48 years old. A late starter, he did not enter the service of the Emperor Ferdinand until he was in his mid-30s. By 1575, when this portrait was done, he had been at the Hapsburg court for 13 years, and had developed and established the distinctive style for which he became famous. In the top left-hand corner, Arcimboldo has signed his name in sepia: 'Joseffi Arcimboldo imago' (the likeness of Joseph Arcimboldo), 'Joseffi' being just one of the various ways in which the artist spelled his name.

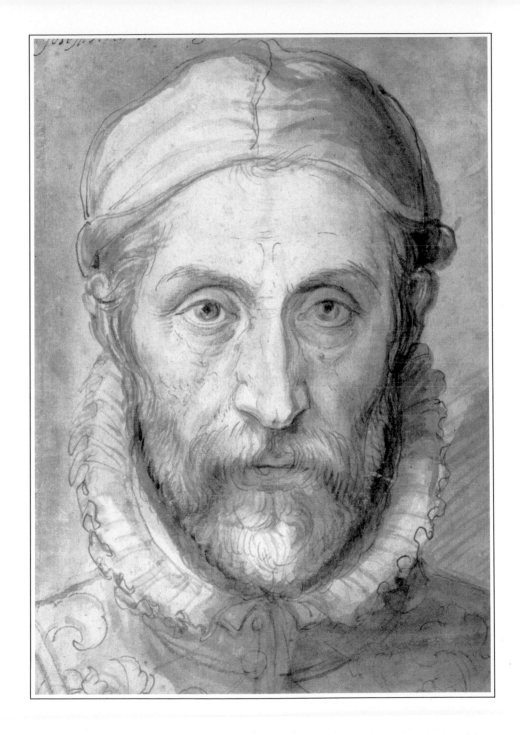

Detail

▷ **Maximilian II and His Family** c. 1553

BELIEVED TO HAVE BEEN PAINTED around 1553, only four years after Arcimboldo began practising as a professional artist, this family portrait shows no hint of the style he was later to develop. On the right stands Maximilian, who would only have been about 26 years old at this time. Interestingly, he was born in the same year as Arcimboldo, thus making the sitter the same age as his portrait painter. On the left is Maximilian's wife, Maria of Spain, and between them the children, Anna, later Queen of Spain, Ernst, and the infant Rudolph II, born in 1552. The date of the painting places it well before Arcimboldo's career as a court painter began, but it is significant in that it shows both Maximilian and Rudolph – the two men who were to be so influential in his life. Nine years after the portrait was painted, Maximilian would become King of Bohemia and Holy Roman Emperor – and nine years later, Arcimboldo would become his court painter.

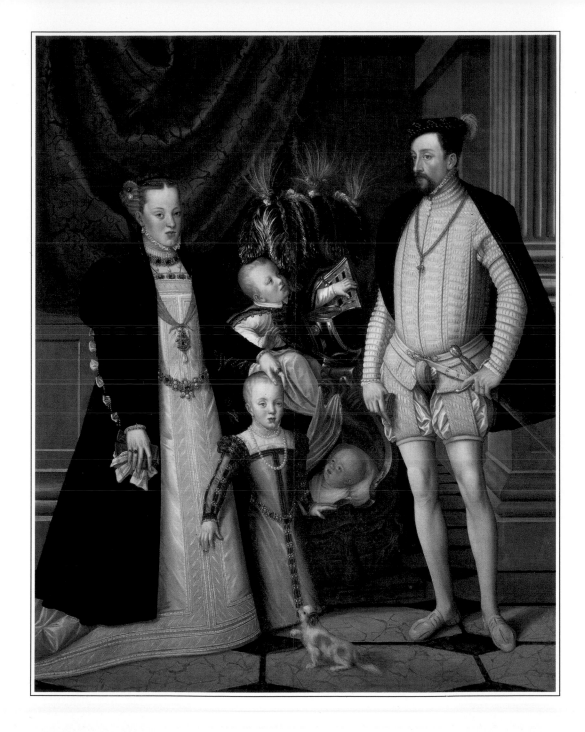

Detail

▷ **Spring** 1563

Oil on oakwood

THIS PAINTING OF SPRING, now in Madrid, belongs to the first known series of the *Four Seasons*, that Arcimboldo produced for Ferdinand I, his first patron. In this profile, we see a perfectly recognizable figure, although not one made up of ordinary flesh and blood, but rather of a mass of fresh flowers and spring greenery. The idea of portraying the seasons as people was not new, and went back to Roman times; what was new, however, was Arcimboldo's idea of constructing each head out of natural objects appropriate to the season – flowers for Spring, fruit for Summer, and so on. This bold concept marked a turning point in Arcimboldo's artistic career, and laid the foundations for his fame. In fact, the *Four Seasons* theme proved so popular with his imperial protectors that Arcimboldo would be asked to paint it again and again.

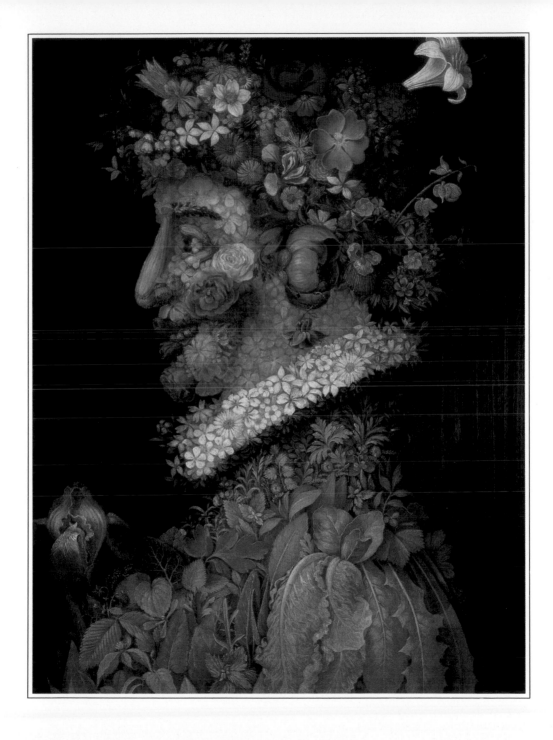

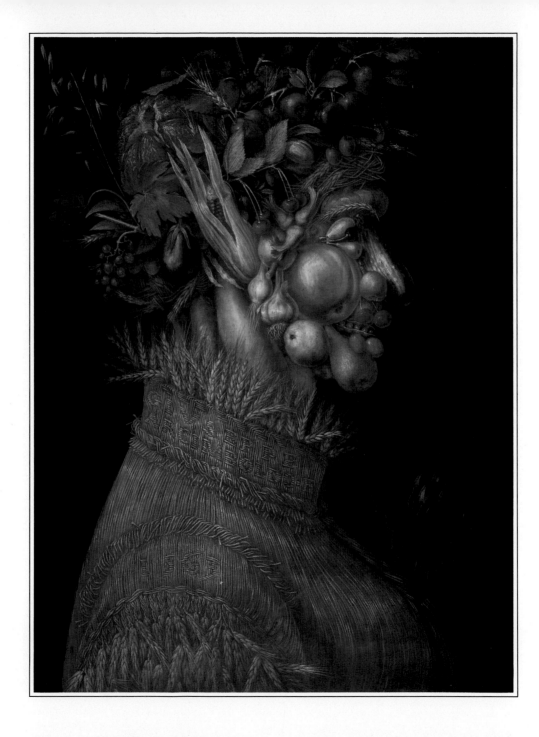

Detail

◁ **Summer** 1563

Oil on limewood

IN COMPARISON WITH the freshness of *Spring, Summer* is glowing and mellow, the richness of the colours emphasized by the blackness of the background. The head is appropriately made up of seasonal produce, all of which is rendered in such careful detail as to be easily identifiable. In building up the head, Arcimboldo has cleverly used fruits and vegetables that are closest in shape to the features they represent – so a ripe apple becomes the full, rounded cheek, an oval pear the chin, and what appear to be cucumber and a pod of young peas make up the nose and the row of pearly teeth. The straw hair is crowned and hung with plums, cherries, grapes, a bursting, overripe melon, and cloves of garlic. On the figure's collar we can see the words 'Giuseppe Arcimboldo F (for *fecit*, or 'made this'), and on the shoulder, 1563, the date the picture was painted.

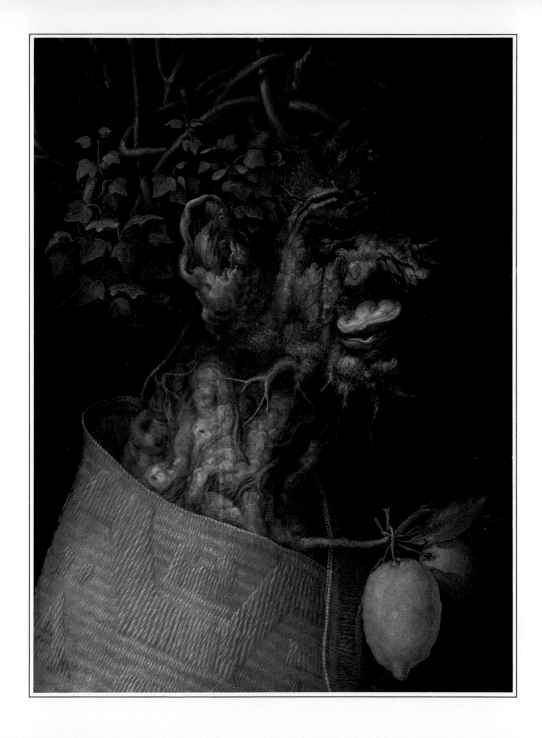

Detail

◁ **Winter** 1563

Oil on wood

ALONG WITH *SUMMER*, this painting of the final season, *Winter*, now resides in Vienna. The intervening season in the 1563 series – *Autumn* – has been lost. Unlike *Spring* and *Summer*, whose heads are constructed of separate elements, the head of Winter is primarily made up of a single trunk and branches. The gnarled and twisted nature of the wood perfectly conveys the lined and wrinkled surface of the 'old man's' face. In this apparently dormant season, there are still signs of life, however, as in the green ivy 'hair' at the back of the head, while the orange and lemon provide a welcome splash of colour in the dark, short days of winter.

Detail

▷ **The Lawyer** 1566

Oil on canvas

PAINTED DURING THE REIGN of Maximilian II, *The Lawyer* – also known as *The Jurist* – shows Arcimboldo turning from allegory to caricature, for this is the portrait of an actual person. There is, however, some contention as to the subject of the portrait. According to some authorities, it represented Johann Wolfgang Zasius, the administrator in charge of the imperial fianances; according to others, John Calvin, the Protestant religious reformer. Composed of poultry and fish – including a plucked but still live chicken clamped to the front of the face – this grisly portrait can hardly have been flattering, yet was said to be such a good likeness that everyone immediately recognized whom it was meant to represent. Interestingly, the body is made of nothing more than books and papers – perhaps the artist's comment on his subject's character.

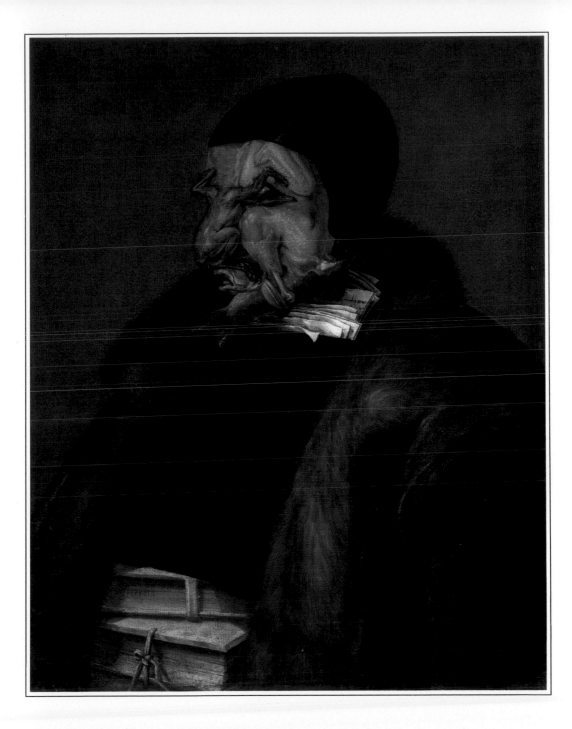

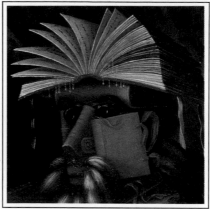

Detail

▷ **The Librarian** 1566

Oil on canvas

ALMOST THE ENTIRE VISIBLE
BODY, including the face, of this
figure are made up of the 'tools of
his trade': books. An open book
cleverly becomes the librarian's
hat, another book, propped up at
an angle, forms the rather sharp
nose, while larger tomes on the
left of the figure become the
shoulder and folded arm holding
other books, with ribbon markers
for the 'fingers'. This painting
was, in fact, a portrait of a living
person, the scholar and
antiquarian, Wolfgang Lazius,
one of the intellectual coterie at
the imperial court.

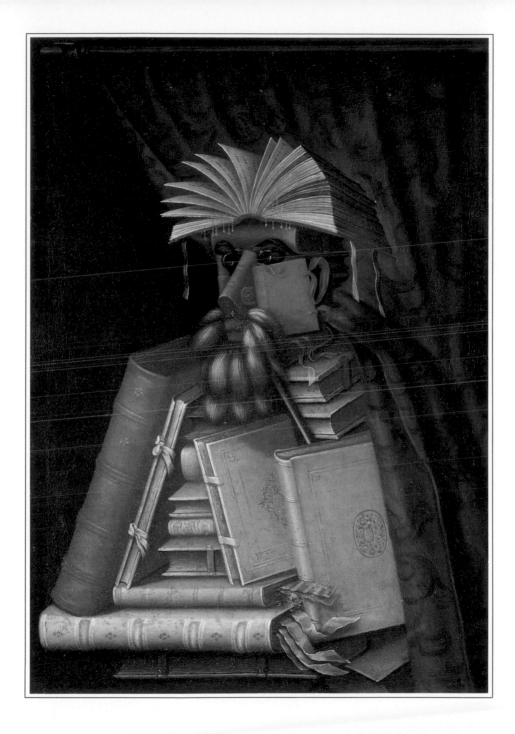

THE FOUR ELEMENTS

1566-c. 1570

Taken INDIVIDUALLY, each of the *Elements* contains its own meanings and symbolism; taken as a whole, the series reveals the multi-layered nature of its significance, that typifies the way in which Arcimboldo's pictures can be interpreted on different levels. As well as being a proficient artist, Arcimboldo was also a highly educated man, and would have been familiar with the ideas of the ancient Greek philosophers, such as Plato and Aristotle. According to Greek (and mediaeval) thought, the four elements were the substances from which everything in the world was composed. They were further unified by a fifth element, the *quinta essentia* or 'quintessence'. So, in portraying all four elements together, Arcimboldo is, in a sense, portraying the whole of creation. Add to this the very obvious Hapsburg references contained in the pictures, and the 'whole of creation' becomes synonymous with the Empire: in other words, the Hapsburgs are masters of the world.

Opposite:
Top: *Fire.* Bottom: left, *Earth*; right, *Water*

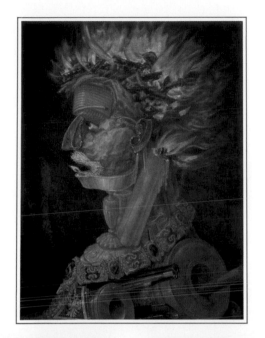

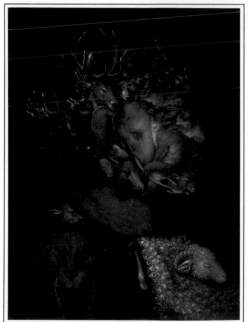

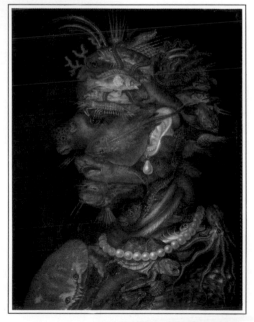

Detail

▷ **Water** 1566

Oil on limewood

LIKE THE *FOUR SEASONS*, the *Four Elements* was to be a theme which Arcimboldo would be asked to paint many times. Unfortunately, only two of the elements in the 1566 series are still known to be in existence. These are *Water* and *Fire*, which are housed in Vienna; *Air* and *Earth* cannot be traced. Arcimboldo's paintings are rich with symbolism, and this version of *Water* is no exception. The head of the fantasy figure is suitably constructed from a rich variety of sea creatures, piled on top of each other to form the whole. Closer examination of the individual creatures begs a question, however: how can a predator like the shark that makes up the mouth exist in such peaceful proximity to the ray forming the cheek? Or the octopus on the shoulder lie so quietly near the turtle? A glimpse of a coral crown on top of the head provides an answer: only under the benign rulership of Maximilian II can all the world's creatures, including man, be at peace.

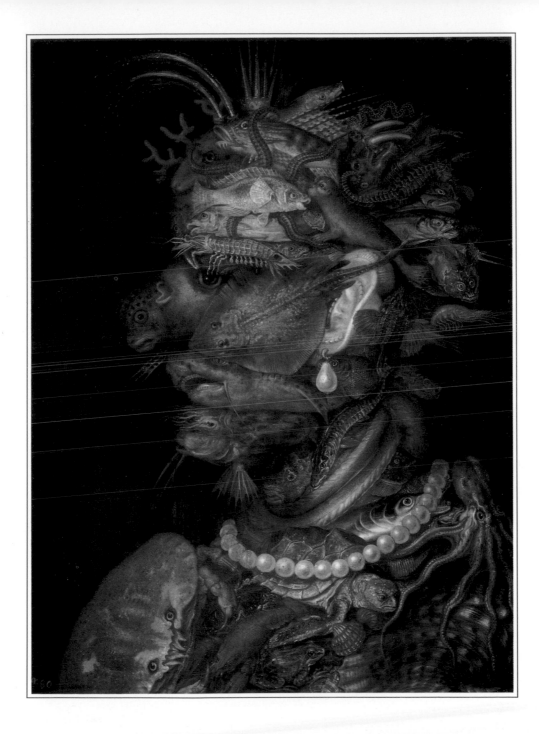

Detail

▷ **Fire** 1566

Oil on limewood

WITH ITS SHOCK OF fiery hair and coronet of charred wood, this portrait is the companion to *Water*, painted in the same year. In this allegorical picture, Arcimboldo shows various different sources of fire. The lower lip, chin and front of the neck are formed by a lighted oil lamp, while a candle shapes the side of the neck, its flame adding to the hair. A smaller candle, with a blackened wick, makes up the eye and lashes, while a coiled-up taper forms the furrowed brow. In some of its symbols, *Fire* pays direct homage to the artist's Hapsburg employer. The chain around the figure's neck represents the Order of the Golden Fleece, one of the most important orders of the day and one that was donated to the Hapsburgs in 1429 by Duke Philip of Burgundy. Next to the head of the golden ram we can see the emblem of the double eagle, the symbol of the Holy Roman Empire, of which the Hapsburgs were then rulers. The gun and cannons at the base may also have been included to symbolize Imperial military power.

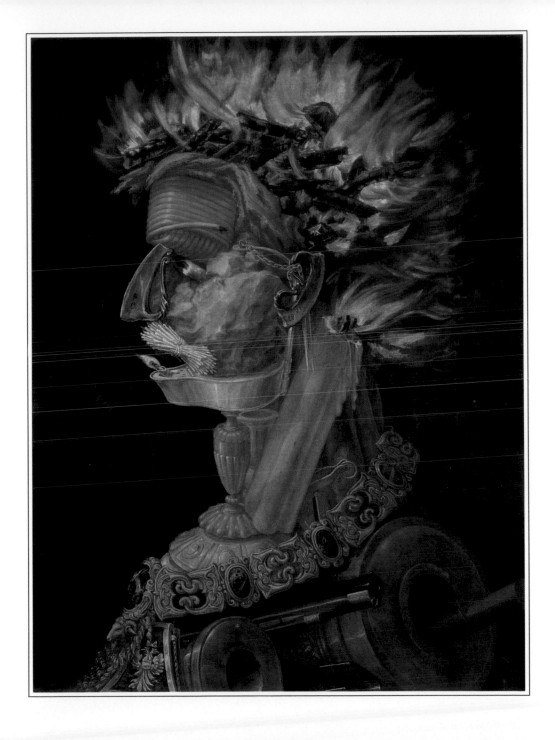

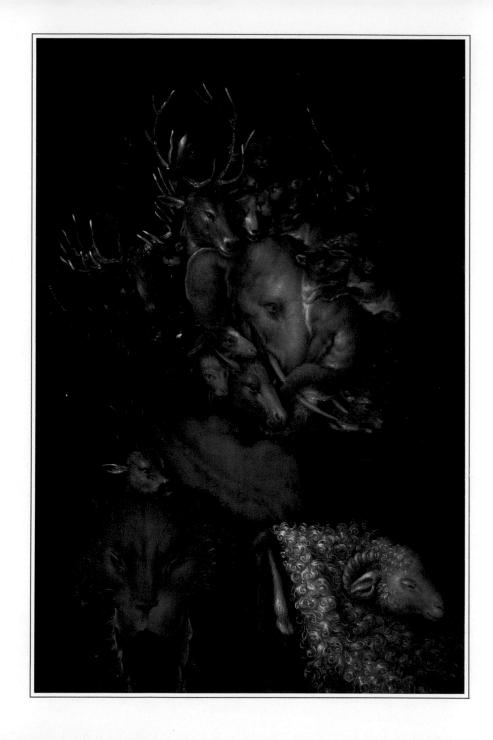

◁ **Earth** c. 1570

Oil on wood

PERHAPS MORE DIFFICULT to
interpret as a head than some of
Arcimboldo's other pictures, this
painting was once thought to
depict a hunter. In a comparatively
compact space, the artist has
managed to squeeze in a veritable
Noah's Ark of animals. In the
forehead alone can be seen two
fallow deer, a red deer, a leopard, a
gazelle and a dog. An elephant's
own ear forms the figure's ear,
while a leopard, making up the
chin, props up a wolf, whose
rounded back creates the curve of
the cheek, and whose open mouth
forms the eye. A hare, clinging to
the wolf's back, stands for the
nose, while a cat's head makes up
the upper lip. Arcimboldo has
cleverly arranged the heads of the
various deer so that their antlers
protrude above the head to form a
crown – another allusion, as in
Water, to the benevolent Hapsburg
influence: under Maximilian, it
implies, the lion will indeed lie
down with the lamb.

Detail

Air undated

Oil on canvas

THIS PAINTING IS currently in
a private collection, and
unavailable for reproduction, but
it is useful to include a description
of it. Just as *Water* is contructed
from fish and crustacea, and *Earth*
from land animals, so the figure of
Air is formed from those creatures
that inhabit the element – the
'fowl of the air'. As in *Earth*,
Arcimboldo has reserved the
larger forms for the face, neck and
body, while a cluster of birds'
heads, beaks pointing outwards,
creates the hair. Among them can
be seen some exotic species – such
as the turkey that forms the nose,
and the parrot, peeping out from
the peacock. The latter, with its
tail magnificently fanned out to
create the bulk of the body, is
another symbol of the House of
Hapsburg, as is the eagle, visible
in the shadows behind the parrot.

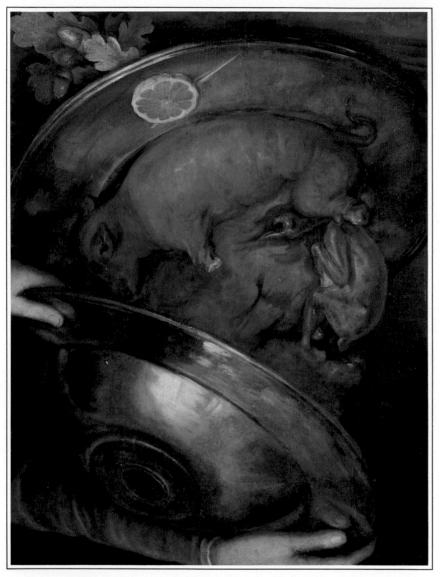

◁ **The Cook** 1570

Oil on canvas

WITH THIS PAINTING, Arcimboldo explored new avenues of inventiveness. Each of the *Seasons* and *Elements* were, at the same time, portraits and very cleverly composed still-life arrangements. *The Cook* goes one step further, for it can be looked at from two separate viewpoints, each of which presents the onlooker with a different, but still intelligible, image. When viewed with the hands holding the lid at the top of the picture, we see a dish of cooked meats, with a slice of lemon for garnish.

▷ **The Cook** 1570

WHEN THE PAINTING opposite is turned the other way round, so that the lid is now at the bottom, a grotesque head emerges, grinning as if to say, 'Look, I was here all the time, you just didn't see me.' The head is assumed to be that of the cook who prepared the dish of meats – the creation has been transformed into the creator. The chicken that the cook produced has become his bulbous, hooked nose, the suckling pig his forehead, the rim of the dish has turned itself into a helmet or hat, and the lemon provides a rakish decoration. With its dual message, this painting helps to explain why the Surrealists took such an interest in Arcimboldo's pictures – pictures that contain layers of meaning.

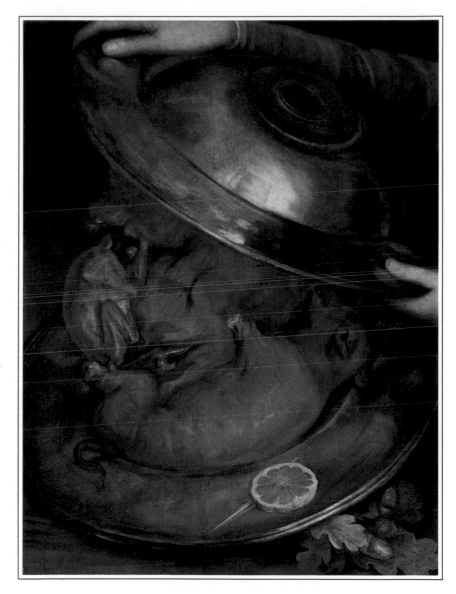

THE FOUR SEASONS

1573

Arcimboldo painted each of the seasons in profile so that they could be viewed in pairs. *Winter* faces *Spring*, and *Summer* faces *Autumn*, revealing the relationship intended between each pair. Paradoxically, although *Winter* is clearly an old man and therefore at the end of the sequence, Arcimboldo has placed him at the beginning, to create a visual pun. The Romans saw winter as the start of the year, calling it *caput anni*, or 'head of the year'. In the same way, the Holy Roman Emperor could be said to be *caput mundi*, 'head of the world', as represented by the wholeness of all four seasons. An incomplete inscription on the back of the 1563 version of *Spring* also implies that the artist intended to pair seasons with elements. The correspondences may have been based on the ancient theory of the *humours*, in which human character and health were said to depend on combinations of the four qualities – hot, cold, dry and wet. *Spring*, seen as hot and wet, would correspond to hot, wet *Air*; hot, dry *Summer* to *Fire*; cold, dry *Autumn* to *Earth*; and cold, wet *Winter* to *Water*.

Opposite:
Top: left, *Winter*; right, *Spring*
Bottom: left, *Summer*; right, *Autumn*

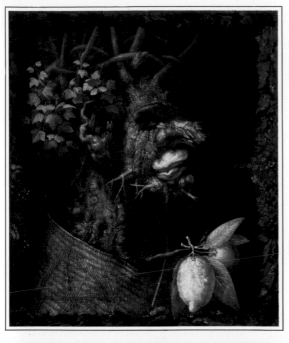

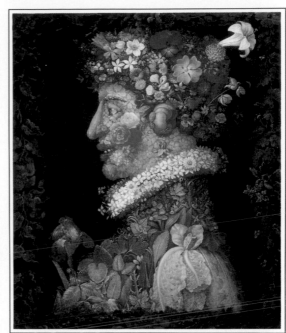

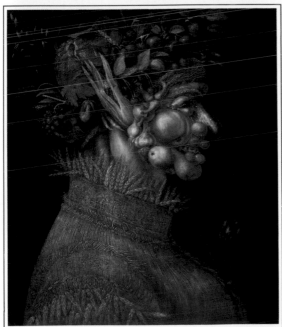

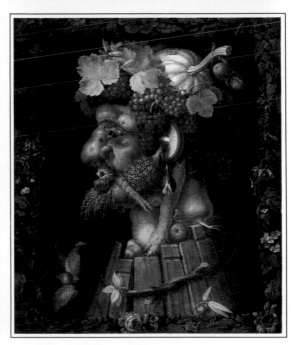

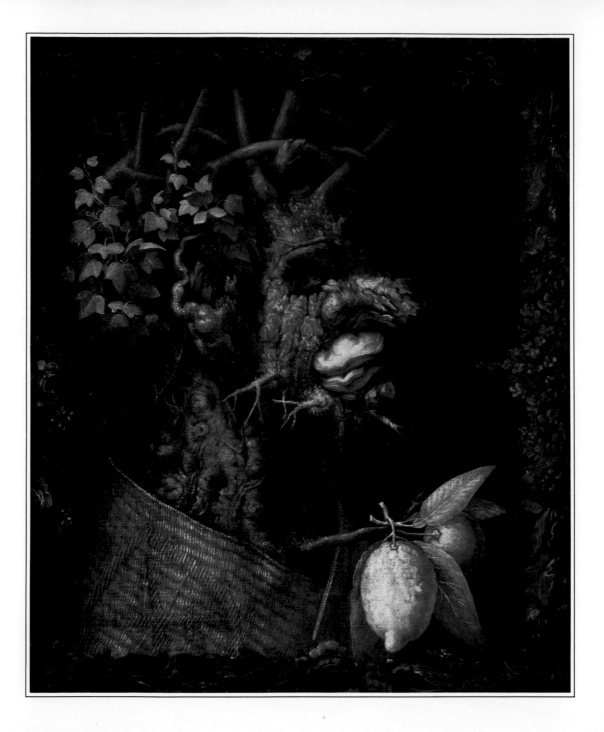

Detail

◁ **Winter** 1573

IN 1573, HAVING ALREADY painted two earlier versions of the *Four Seasons*, Arcimboldo embarked on a third and a fourth series. The series shown here was commissioned by Maximilian as a gift for the Elector of Saxony, and is now housed in the Louvre. Because it is a complete set, it is possible to compare how the seasons age as they progress through the year. The gnarled old age of *Winter* both ends and begins the series. The figure's cheeks are shrunken and hollow, while two mushrooms, growing out of the stump, stand for the sunken, toothless mouth. The straw cloak is marked with the crossed swords of Meissen, in tribute to the painting's Saxon recipient, instead of the crowned M that distinguishes those versions produced for Maximilian. Although the *Seasons* were painted for Christian monarchs, they conjure a distinctly pagan mood: these are beings of Nature. *Winter*, especially, resembles some primitive Green Man, a creature of wicker, leaves and boughs, an inhabitant of the forest.

Detail

▷ **Spring** 1573

Oil on canvas

As the cycle of the seasons moves inexorably on, Winter gives way to *Spring*. On studying the paintings, it becomes clear that each figure represents one of the traditional four ages of man. *Spring*, therefore, as a time of regeneration and hopeful beginnings, represents youth – the first age – all budding blossom and new growth. Not only is the face composed of appropriate spring flowers and plants, but its features are also clearly those of a young person, as yet unweathered by time. The garlands surrounding the painting have been rendered in a looser style than the rest of the picture, and are therefore thought to have been added later.

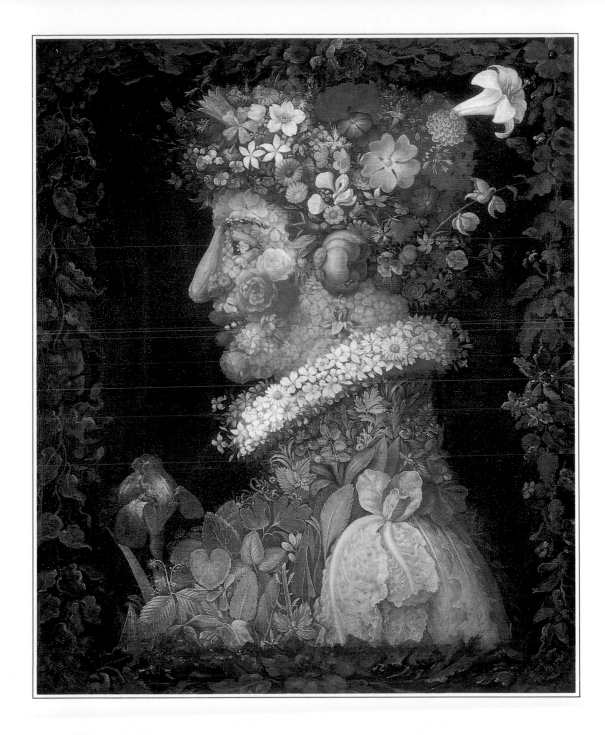

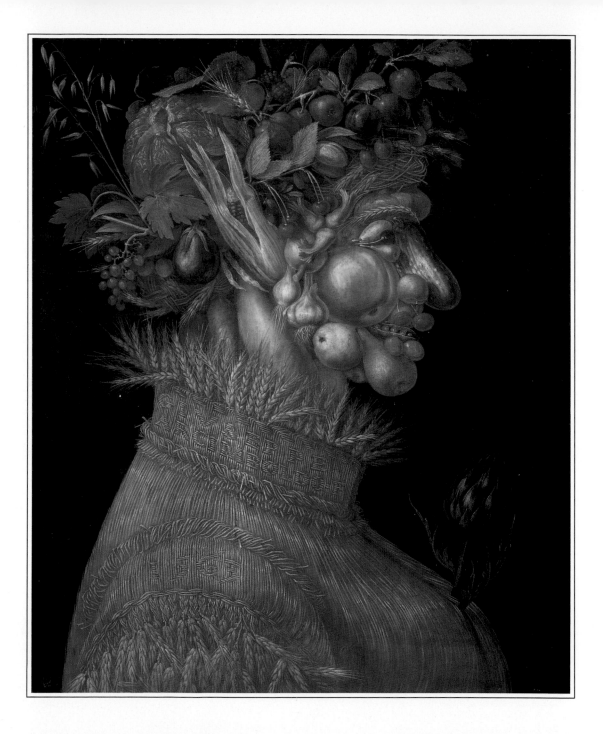

Detail

◁ **Summer** 1573

Oil on canvas

As the months pass, *Spring* passes from boyhood and develops into the young man that is *Summer*. The blossoms of the former season have fallen to produce new fruit, and more robust forms have emerged, particularly the full, rounded cheek shaped by a rosy apple. Apart from the flowery frame, the painting is very similar in detail to the 1563 version, even down to the artist's 'signature' on the collar, and the date on the shoulder.

Detail

▷ **Autumn** 1573

Oil on canvas

THE FRUITS OF SUMMER have now ripened into the fully mature figure of *Autumn*, showing all the 'mellow fruitfulness' of the season. A ripe pear is the large, full nose, a bursting, overripe fig hangs from the ear, while a pomegranate creates the chin. The pomegranate is a particularly apt fruit to symbolize the passage from summer to winter. In Greek myth, it was the fruit eaten by Persephone, daughter of Demeter, the Earth Goddess, to mark her union with Hades, god of the Underworld, who had stolen her away. On the kidnap of her daughter, an angry Demeter refused to allow anything to grow, so creating winter. Only when her daughter was returned did she permit the earth to burgeon again, creating spring. The bunches of grapes with which the head is laden, and the barrel body suggestive of wine, are also reminiscent of Bacchus, the Roman god of wine.

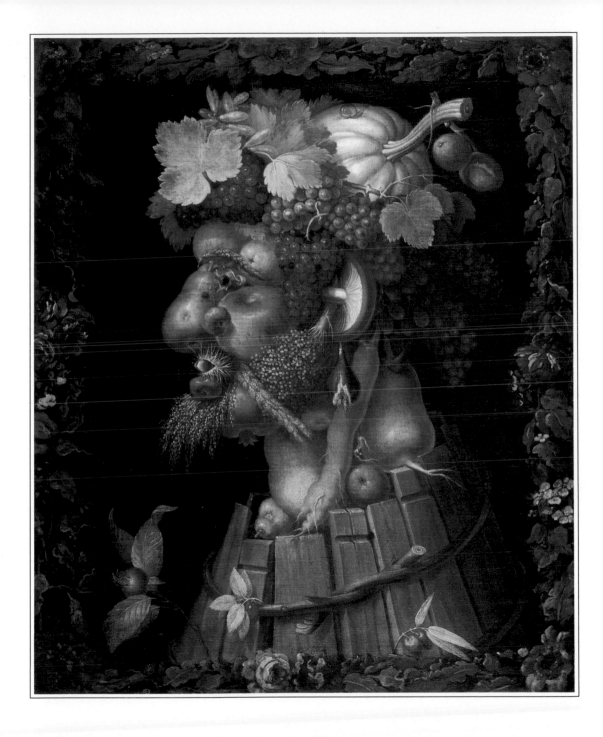

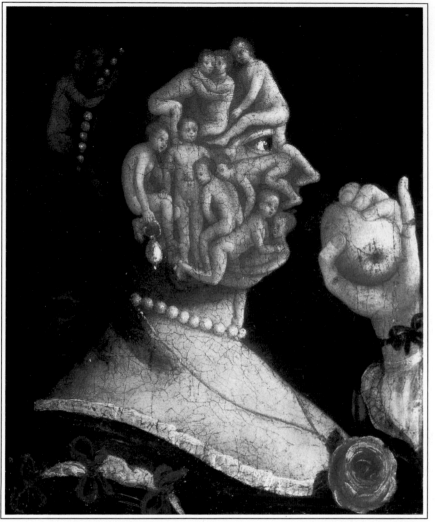

◁ ▷ **Adam and Eve** 1578

Oil on canvas

THIS RATHER DISCONCERTING pair of heads are composed of naked children – perhaps fitting subject matter for the Mother and Father of Mankind. The wriggling, writhing forms in each head appear to move almost before our eyes, and form a strange and uncomfortable contrast to the stillness of the body below, painted in a conventional way. In her hand, Eve holds the fateful fruit, while Adam clasps a book and brandishes a manuscript with an unreadable inscription. The figure forming Eve's ear obligingly holds her pearl-drop earring, while a chubby baby hangs upside down, its hair falling behind its head, to provide Adam with a beard. The rich colours of the paintings, with the heads set in relief against a dark background, is very typical of Arcimboldo's style. Eve, in particular, has not weathered her age well, for the paint surface is heavily cracked.

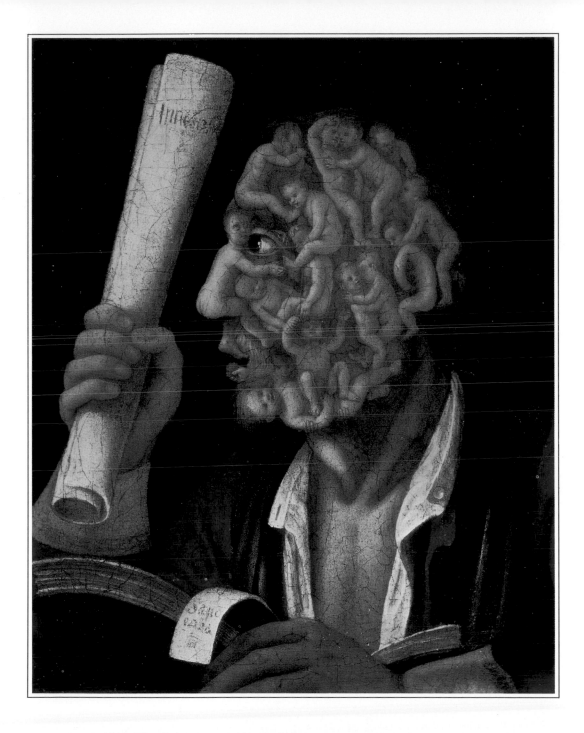

Detail

▷ **Headdress Design** c. 1571

THIS DESIGN FOR a woman's headdress is one of 150 drawings that Arcimboldo presented to Rudolph II in 1585. They show his work as a costume designer, devising costume ideas for the processions, masquerades and balls of which the Hapsburg court was extremely fond. Most of the designs were in fact produced for the celebrations that marked the wedding of the Archduke Charles of Austria to Mary of Bavaria in Vienna in 1571, when Maximilian was on the throne. At such festivities, members of the Imperial family and the nobility would dress up as allegorical figures, representing gods and goddesses such as Juno, Diana, Venus and Neptune, qualities such as Fortitude, Temperance or Greed, or characters from the arts and sciences such as Geometry, Arithmetic, Rhetorick, Musick and Astrology. Nothing escaped Arcimboldo's attention – there were decorated sledges on which the participants could ride, and even costumes to turn the horses into dragons!

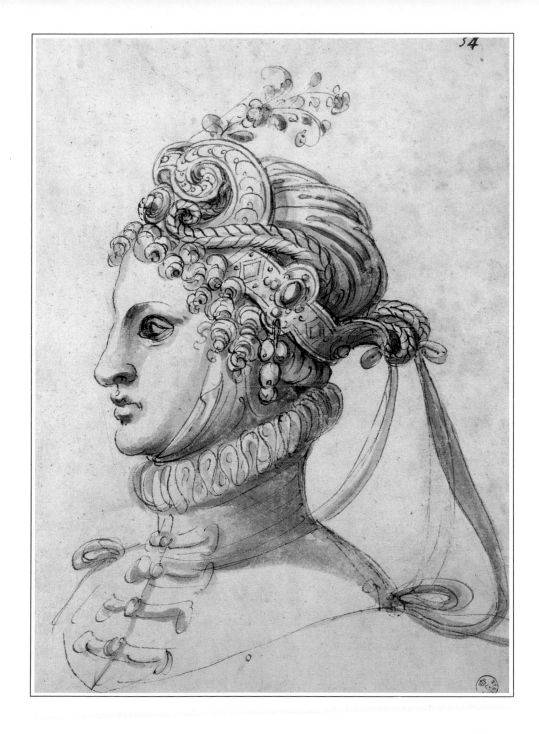

PROCESSING OF SERICULTURE

1585

Pen, blue ink and watercolour on paper

THIS SET OF 13 DRAWINGS of the silk-making process were produced for Rudolph's financial adviser and court treasurer, Baron Ferdinand Hoffman von Grünpichl und Strechau. The Baron was due to redecorate the rooms of his palace, and Arcimboldo suggested that he might adorn the walls with 'drawings', as the Romans had done. In his accompanying letter, Arcimboldo first apologizes for the sketchiness of his designs; this was due, he says, to pressure of other work for 'His Holy Imperial Majesty my Lord'. He then goes on to explain how modern murals could employ a more contemporary theme than those of the Romans: 'I have thought that the moderns likewise will be able to place illustrations of textiles in the rooms…in these sketches I depict the production of silk…in another room we could depict the making of wool and in yet another the making of canvas…'. The subject matter of these drawings reveals the breadth of Arcimboldo's interests. With an almost child-like fascination, he wanted to find out how the world worked – to discover all the secrets of nature and science.

▷ Processing of Sericulture:
Drawing 1 1585

EACH OF THE DRAWINGS in the series carries a caption, describing which stage in the process is being shown. Here, two women are turning over a basket of eggs. The words read: 'This chapter demonstrates how the silkworm develops. At the start of spring, when the weather is warm, women gather the "seed" [the eggs] and keep it against their skin. With the help of this warmth, it [sic] begins to move [come alive or hatch].' The silkworm is actually the caterpillar of the *Bombyx mori* moth. Like all insects, it metamorphoses through three different stages – egg, caterpillar or larva, and cocoon or pupa – before it can become an adult moth. The caption goes on to describe the relative sizes of the insect at each of these stages.

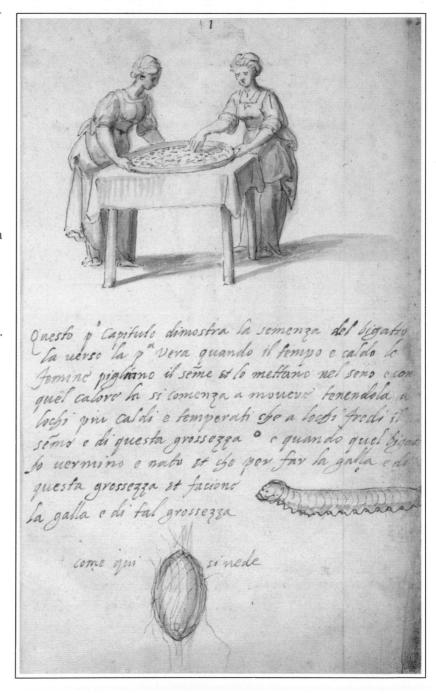

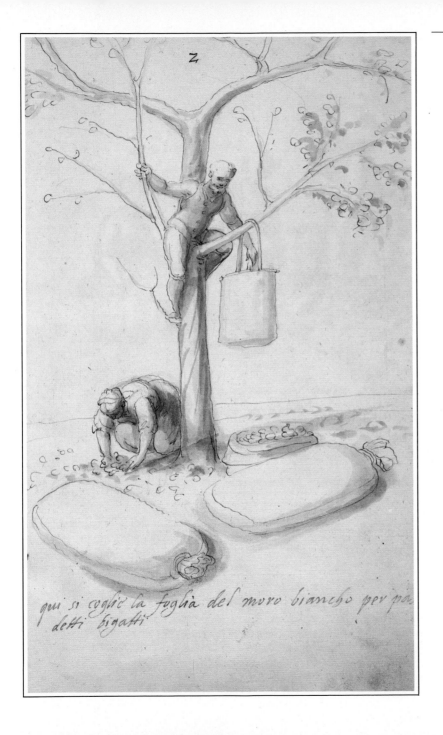

◁ **Processing of Sericulture:**
Drawing 2 1585

NOW THAT THE SILKWORMS have hatched, they need feeding. Caterpillars are generally voracious feeders and may eat almost continuously, to fuel their growth and to build up reserves both for the pupal stage to come – in which they will metamorphose into moths or butterflies – and for their short-lived adulthood, during which they survive on a light diet of flower nectar. Silkworms feed on the leaves of the white mulberry tree. The women here are collecting leaves by the sackful, clearly to ensure that the caterpillars are not undernourished. The short identifying caption reads: 'Collecting the leaf of the white mulberry to feed the silkworms.'

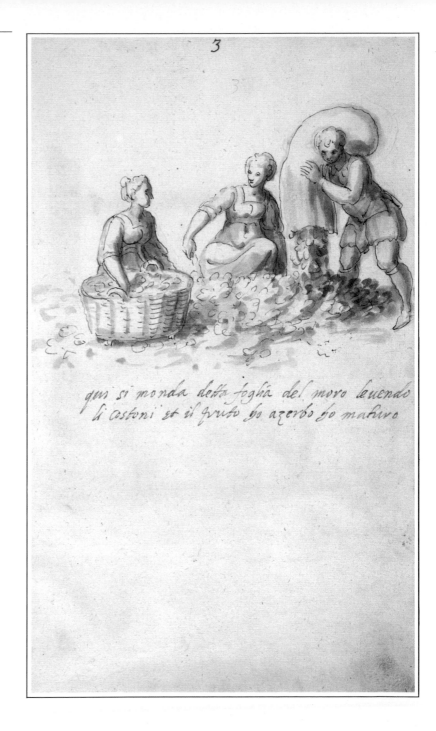

qui si monda detta foglia del moro leuendo
li costoni et il frutto ho azerbo ho maturo

▷ **Processing of Sericulture:**
Drawing 3 1585

'CLEANING THE LEAVES of the
mulberry': the women tip out the
huge sackfuls of leaves they have
collected, and sort through them.
The selected leaves are piled into
large baskets, ready to be carried
to the silkworms, which have been
spread out on shelves. The
silkworms will then be able to feed
on the leaves, grow and fatten,
until it it time for them to pupate.

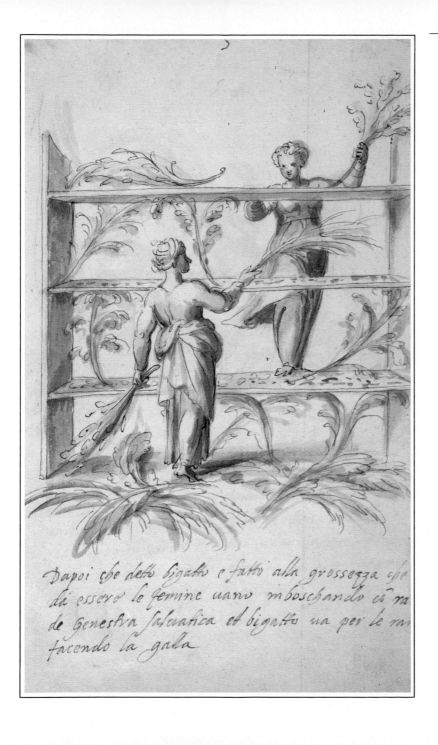

Dapoi che detto bigatto e fatto alla grossezza che
di essere le femine uano inboschando co ra
de Genestra saluatica et bigatto ua per le ra
facendo la gala

'WHEN THE SILKWORM is the right
size,' the caption says, 'the women
go into the woods in search of
branches of wild broom, and the
silkworm crawls into the branches
and makes its cocoon.' The
drawing shows the women
arranging the branches they have
collected on the shelves where the
silkworms have been kept. In order
to pupate, each silkworm secretes a
thread of silk – a liquid substance
extruded from its body, which
hardens on contact with the air,
in a similar way to spider's silk.
With this fine, sticky thread, the
silkworm attaches itself to one of
the branches, suspending itself in
this manner while it continues to
secrete silk, entwining its body in
ever-deepening layers, like yarn
wound around a spool. The total
length of this silk thread may be as
much as 275 metres (900 feet) long.

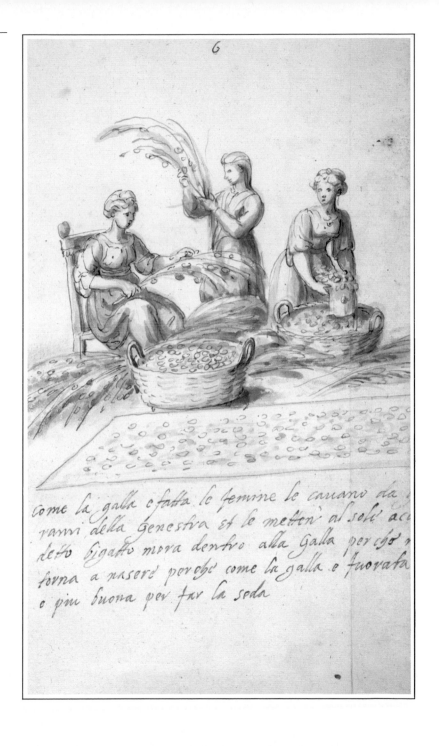

6

come la galla e fatta le femine le cauano da
rami della genestra et le metteno al sole ac...
detto bigatto mora dentro alla Galla perchò...
torna a nasere perchò come la galla e fuorata
e più buona per far la soda

▷ **Processing of Sericulture:** Drawing 6 1585

'WHEN THE COCOONS have been constructed, the women take them down from the branches of the broom...' In the wild, the silkworm would remain inside the cocoon until it emerged as a moth. For silk-making purposes, however, the silkworms must be killed before this point; if allowed to pierce their way out of the cocoon, they will break the thread that forms it and so render it useless for silk making.

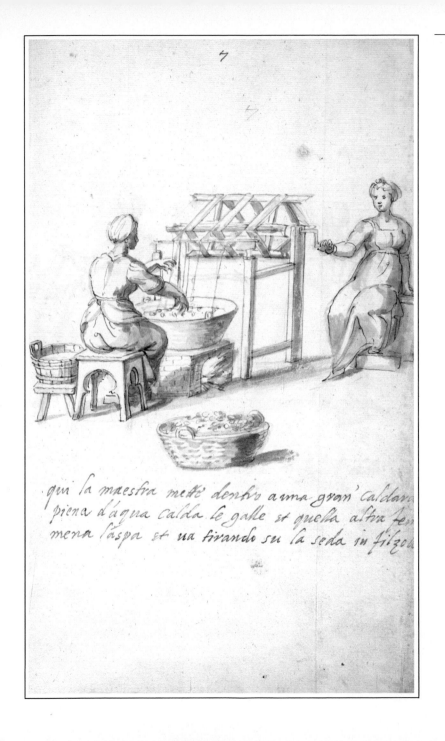

qui la maestra mette dentro a una gran' caldara
piena d'aqua calda le galle et quella altra men
mena l'aspa et ua tirando su la seda in filzou

THE PRODUCTION OF the silk fibre begins: two women use a mechanical device to wind the thread off the cocoons: 'Here the mistress places the cocoons in a large tub of hot water, and the other mistress turns the reel and continuously pulls the silk up into threads.' Arcimboldo's use of the new word 'mistress' implies that this stage of production requires greater skill and experience than the day-to-day care of the silkworms earlier, and that the women here are senior practitioners in their craft.

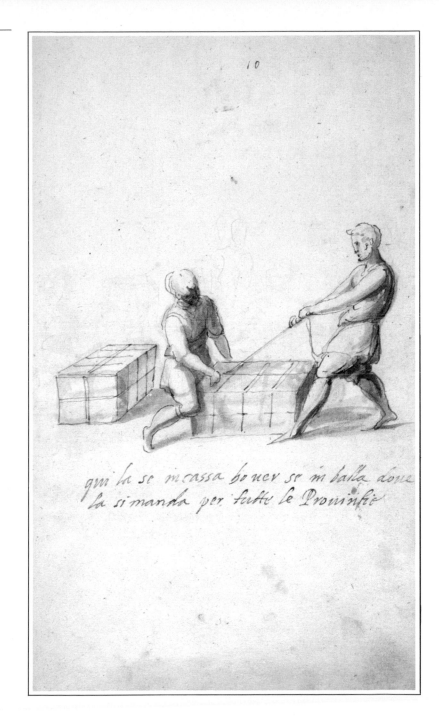

qui la se incassa bouer se in balla doue
la si manda per tutte le Prouinfie

▷ **Processing of Sericulture:**
Drawing 10 1585

'HERE THE SILK is being packed
into bales to be sent to the
provinces.' Manufacture of the silk
fibre is complete, and two men
help each other to parcel it up,
and prepare it for export to other
parts. On arrival at its destination,
it will be processed further, and
finally dyed.

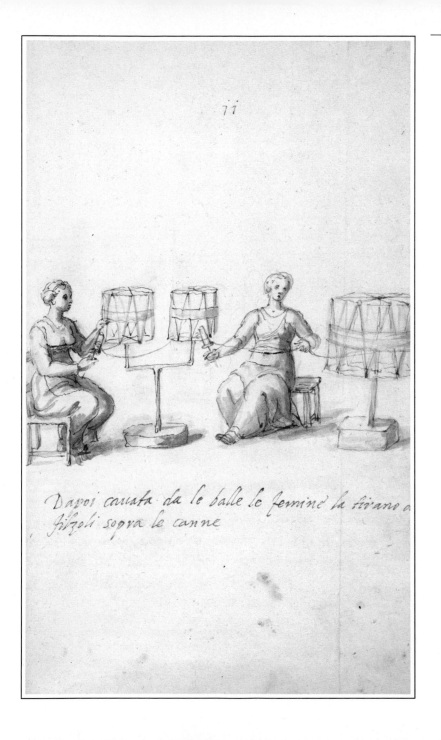

11

Dapoi cauata da le balle le femine la tirano ạ fizoli sopra le canne

◁ **Processing of Sericulture:**
Drawing 11 1585

'ONCE THE SILK has been taken out of its bales, the women pull the threads on to canes.' In this drawing, two women sit and wind the thread off pairs of drums, reminiscent of the more familiarly shaped spinning wheel, and on to the spindles – Arcimboldo's 'canes' – that they hold in their hands.

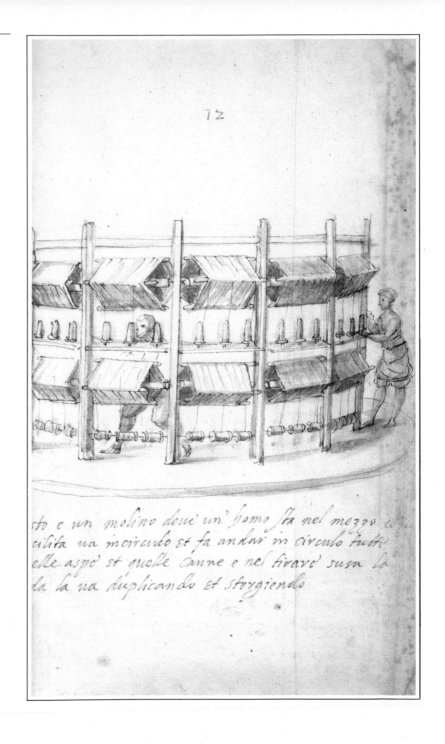

▷ **Processing of Sericulture:**
Drawing 12 1585

THE SPINDLES FROM THE previous drawing can clearly be seen mounted in threes on the central bar of this circular device. Without the benefit of a motor to drive it, this giant wheel had to be powered by hand – the role of the man standing in the middle. Another figure on the outside attends to the silk itself. Loosely translated, the caption reads: 'This is a mill which is rotated by a man standing in the middle, and [the silk on] all the reels and spindles is pulled upwards and doubled over and twisted.'

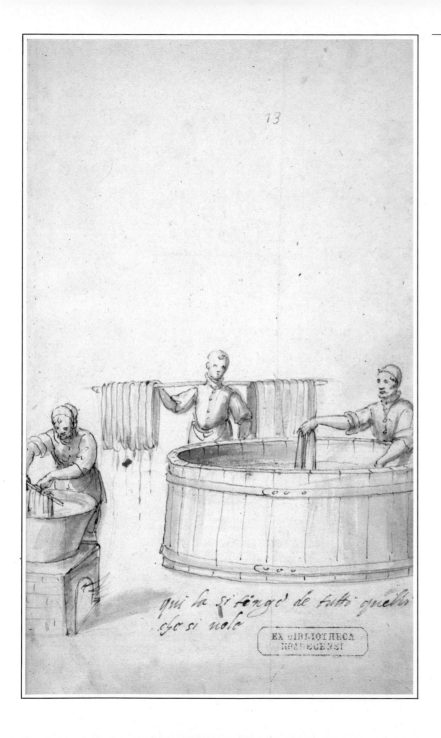

◁ **Processing of Sericulture:**
Drawing 13 1585

ARCIMBOLDO'S FINAL CAPTION
reads 'here everything is dyed'. As
production reaches completion,
the drawing shows three women
involved in the dying process. In
the background, one woman
carries lengths of silk on a rod
across her shoulders. Before her
is a huge vat of dye into which
another woman dips some silk,
while to the left another appears to
be rinsing the silk in a hot tub.

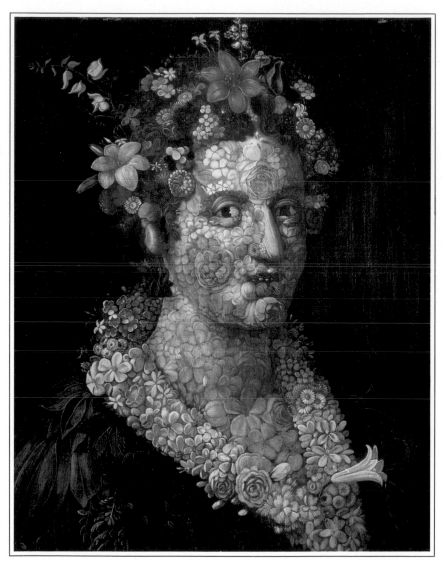

◁ **Flora** 1591

Oil on wood

ONE OF ARCIMBOLDO'S most famous paintings, this was first painted in 1589, after the artist had left Rudolf's court and returned to Milan. Arcimboldo painted this second version in 1591. It shows Flora, the Roman goddess of spring and fruitfulness, entirely composed of various flowers. The yellow lily in the goddess's collar symbolizes fertility. In 1589, Arcimboldo sent his first *Flora* to the Hapsburg court, as a gift to his former patron.

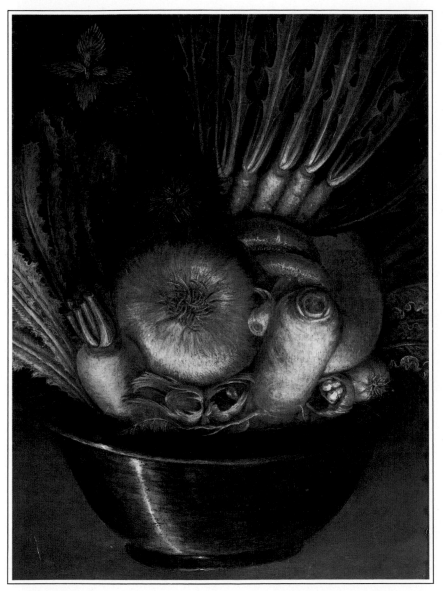

◁ **The Vegetable Gardener**
1590

Oil on wood

LIKE THE *COOK* on page 30, *The Vegetable Gardener* can be viewed one way and then turned upside down and seen as a completely different, but related, subject. It is perhaps an even more fascinating example than the earlier painting of how the mind interprets what the eye sees, and explains why the Surrealists took such interest in the work of Arcimboldo. When viewed the 'right' way up, what we see before us is a bowl of vegetables. Apart from the fact that they appear to be piled up in a rather precarious way, there is nothing out of the ordinary about them – no other image to be read into them.

▷ **The Vegetable Gardener**
1590

Oil on wood

WHEN THE PAINTING is turned
over, however, a total
transformation takes place. What
were vegetables now become the
face of a ruddy, coarse-looking
man – the gardener who grew the
vegetables. The large onion that
was in the centre of the
arrangement becomes the
gardener's fat jowl, the large
parsnip his nose, while the two
mushrooms transform themselves
into a pair of fleshy lips. The bowl
becomes a cap, and the handful of
carrots, with their long tails,
become a bristly beard.

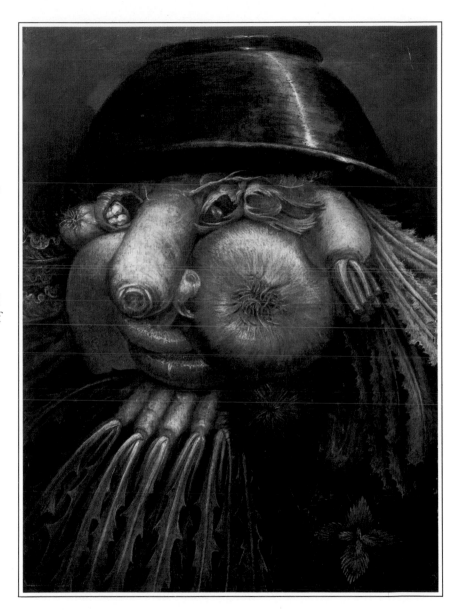

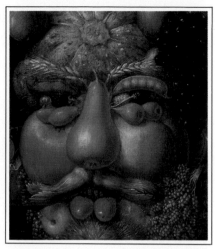

Detail

▷ **Vertumnus** c. 1590

THIS MAGNIFICENT PORTRAIT is a combination of all Arcimboldo's earlier *Four Seasons* series, for it is composed from the fruits, vegetables and flowers of the whole year. It is, in fact, a portrait of Rudolph II, in the guise of Vertumnus, Roman god of agriculture and transformation. Like *Flora*, this picture was painted after Arcimboldo had left the Emperor's service, but the artist sent it to him in Prague, as a tribute, accompanied by a poem by Comanini. In the poem, Comanini flattered Arcimboldo by saying he had painted with 'a brush that far surpasses that of Zeuxis or of those who created veiled deceptions'. Zeuxis was a fifth-century Greek painter famed for his realism. Although Arcimboldo combined objects in a novel way, his style was always strictly figurative. Realism was still the artist's aim – true abstract art was a long way off. The Emperor was delighted with the painting, and it became one of Arcimboldo's most celebrated works.

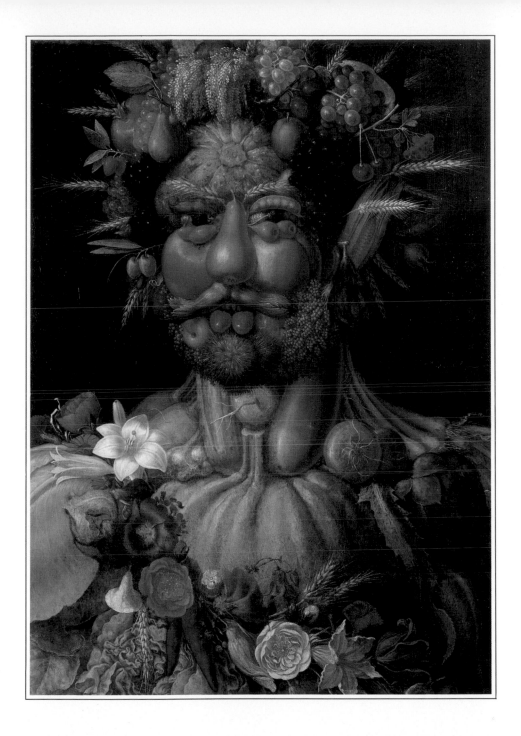

Detail

▷ **The Admiral**

LIKE *WATER*, THIS extraordinary 'composed' head is an intricate construction built up from layered and entwined sea creatures, reflecting the subject's maritime connections. Unlike *Water*, however, which is rich with a myriad of marine life forms, including crustacea, an octopus and a turtle, *The Admiral* is restricted almost entirely to fish, and consequently appears less opulent and exotic. Arcimboldo has cleverly placed a large fish so that its own eye also forms the eye of the figure, while three smaller fish, tails pointing outwards, create a goatee beard. Variety of subject matter is provided by the coronet of writhing eels on the figure's head, the small crab forming the ear, and the chain of office around the figure's shoulders, made up of shells and coral, linked with black pearls.

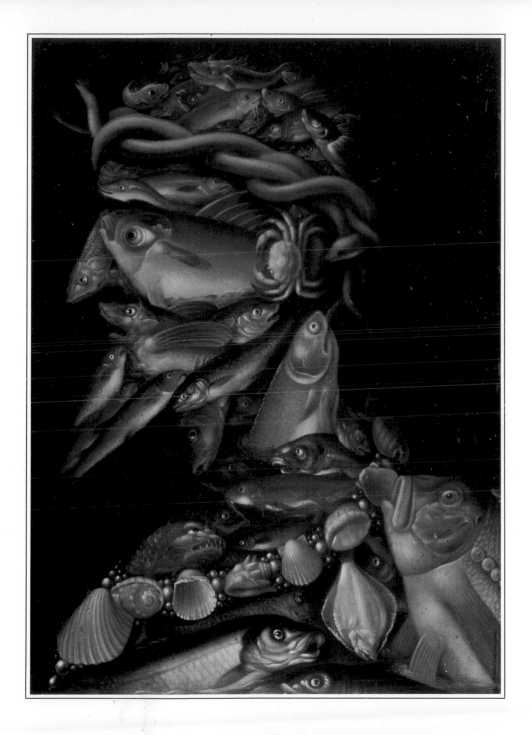

Detail

▷ **The Lady of Good Taste**

ALTHOUGH ATTRIBUTED TO Arcimboldo, this painting lacks the degree of finish which characterizes his technique. Compared with other paintings, too, in which a large number of different forms are combined to create an intricate whole, here the construction is relatively crude and makes use of a limited number of objects – a single, large melon or pumpkin represents the headdress, for example, while two pomegranates create the breasts. The artist has not troubled to compose the eye from some other form, as he usually would, but has given the figure a real human eye. The name of the painting comes from the words on the cards the subject is holding: *alla dona di buon gusta*.

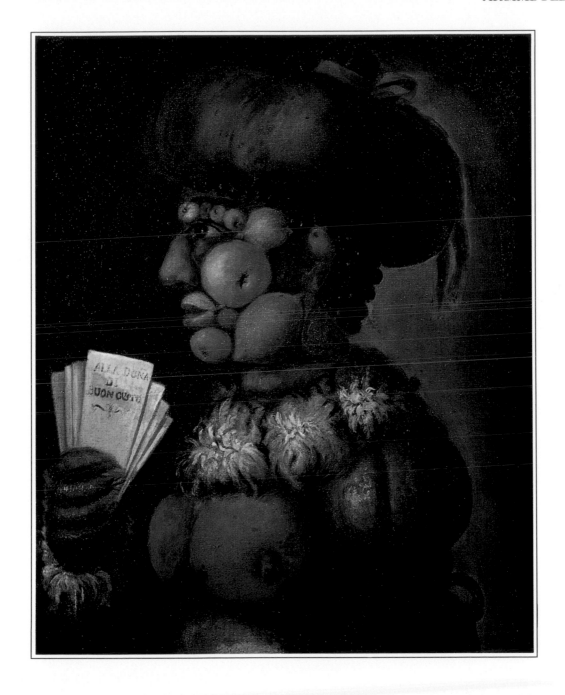

Detail

▷ **Whimsical portrait**

ANOTHER 'COMPOSED HEAD', but this time viewed from the front, instead of Arcimboldo's preferred profile. The glazes used in the painting give it a high-gloss finish, with marked highlights on the various fruits. Crowned with vine leaves and tumbling bunches of grapes, the face has rather bulbous features: apples form the bulging brows and pears the swollen nose and cheeks. In contrast to the fullness of the other features, the eyes and mouth – those features that chiefly give expression to a face – appear mean and pinched. The open-walnut eyes are slewed sideways, and do not look out at the viewer with a direct, honest gaze, while the rosebud mouth, with its raspberry lips, is tightly pursed. Curiously, although the background of the painting is the same dark, rich colour as in the artist's other works, the figure itself is not solid – we can glimpse through gaps between the fruits to the back of the picture.

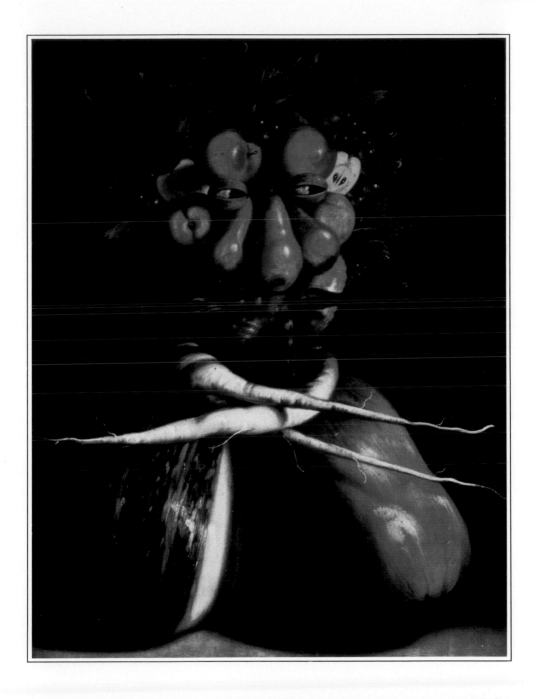

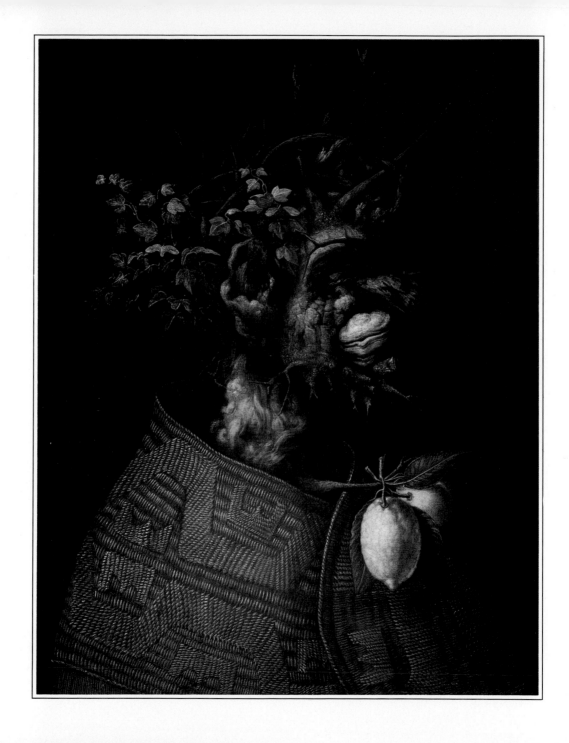

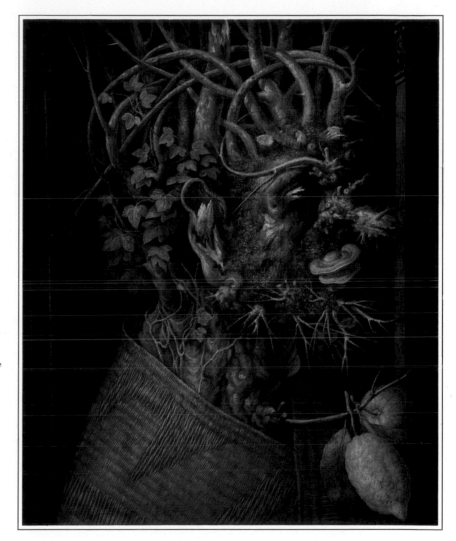

◁ ▷ **Winter**

Oil on canvas/Oil on wood

ARCIMBOLDO'S INNOVATIVE WORK was so popular that it spawned many imitations, for the supply could not meet the demand. Sometimes these imitations were simply based on Arcimboldo's ideas, at other times they were unashamed copies, produced to a very high standard and hard to tell from the original, as in these two paintings of *Winter*: the work on the right is a copy. Since Arcimboldo himself painted more than one version of some of his paintings, the existence of additional copies makes identification even more difficult. As in a 'spot the differences' game, it is fascinating to compare two versions of the same picture. The two paintings here both show the same degree of detail and finish – compare, for example, the finely worked, woven mats that both figures wear, and the delicate leaf 'hair'. Then compare these pictures with the other versions of *Winter* on pages 16 and 34.

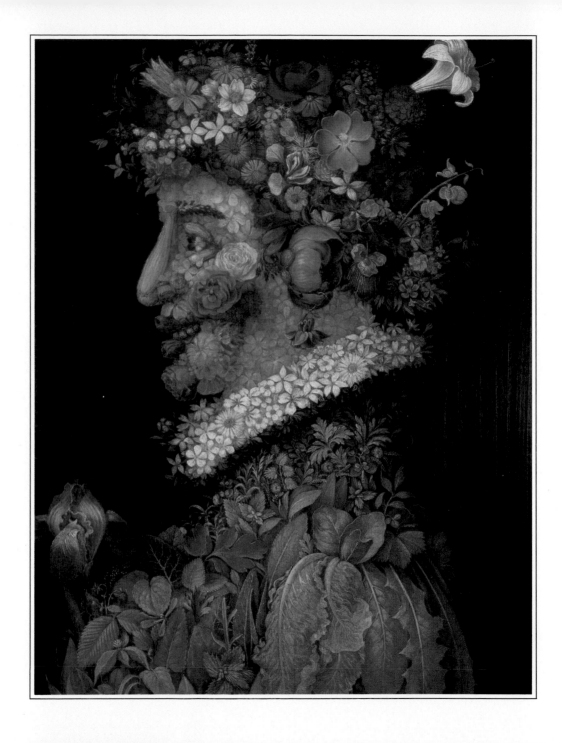

◁ ▷ **Spring**

Oil on wood

AT FIRST GLANCE, these two paintings of *Spring* look so alike that they appear identical. Both heads are made up of a mass of flowers, both painted with the same skill and delicacy of touch – but one of them is not thought to have been painted by Arcimboldo. The 'fake' is the painting on the right, and it is only by comparing the minutest details that one can tell the two pictures apart. Look, for example, at the flowerhead eyebrow: in the right-hand picture, it stretches right across the bridge of the nose, while in the facing work, it stops short. Look, too, at the lily at the back of the head: in one painting, the petals are curved outwards, showing the orange stamens; in the other, they fold inwards, tulip-fashion.

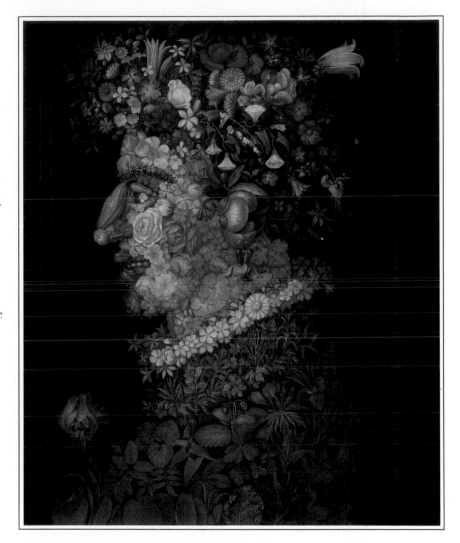

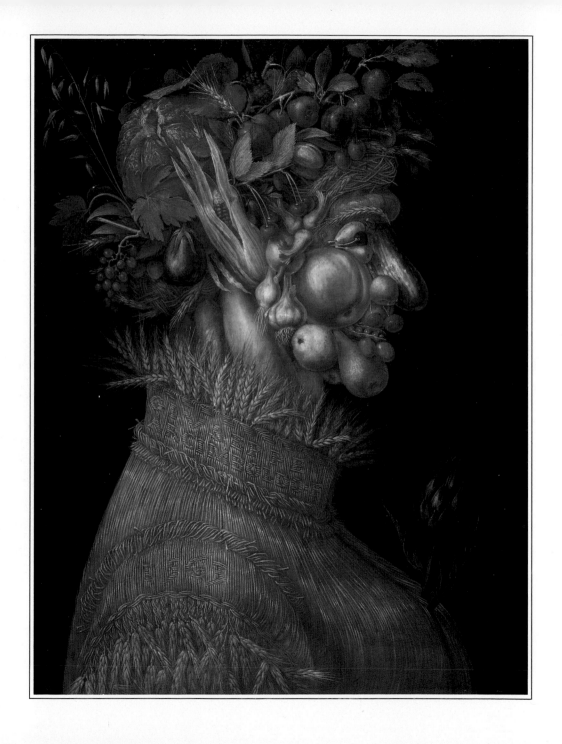

◁ ▷ **Summer**

Oil on canvas/Oil on wood

In this pair of paintings of *Summer*, the one on the right is thought to be a copy, inspired by Arcimboldo's originals. The picture on the left is now in Vienna, and is clearly an original because Arcimboldo has 'signed and dated' it on the collar and sleeve. Seeing these two pictures together demonstrates the skill of Arcimboldo's imitators, for the copy is of such a high standard that both works would appear to be by the same hand. The most striking difference between them is in the garment that *Summer* wears, which in Arcimboldo's version has a more convincing solidity, suggesting the form beneath.

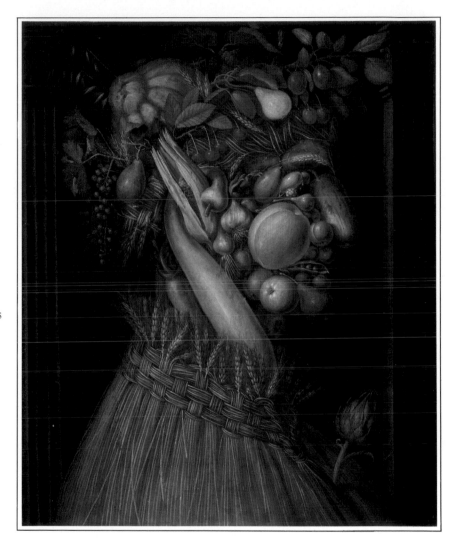

Detail

▷ **Spring** (reclining)

IN THE RICHNESS of its subject matter, its floral opulence, this painting, accredited to Arcimboldo, has very much the quality of a tapestry – and this is no coincidence for designs for tapestries formed part of Arcimboldo's earliest work. Tulips, narcissi, roses, cherries, strawberries, asparagus, and young peas in the pod suggest late spring – even early summer – rather than the first burgeonings of the season. The young lamb in the background is perhaps representative of the lambs that typify spring.

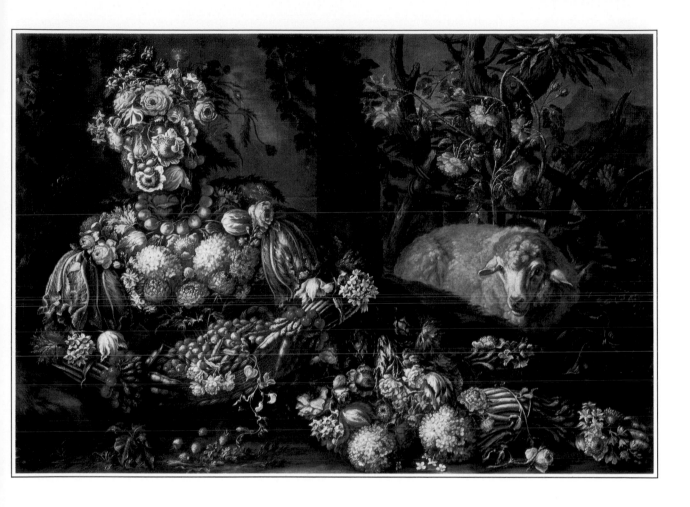

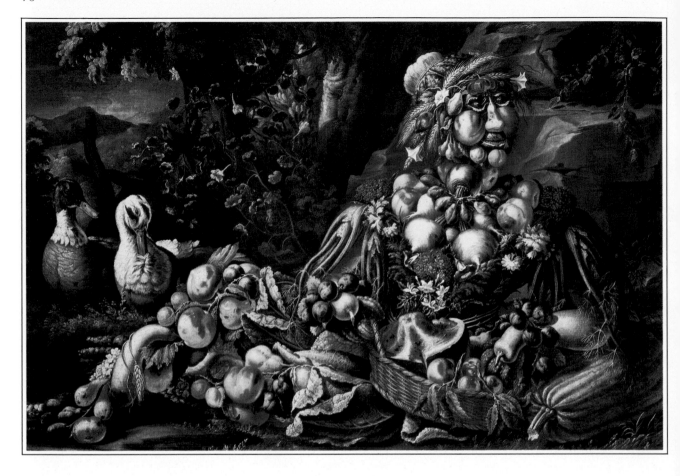

△ **Summer** (reclining)

SET AGAINST THE SAME DISTANT landscape, this figure of *Summer* partners the reclining figure of *Spring*. Here the freshness of the earlier season has given way to the abundance of high summer. Overflowing with ripe melons, pears, peaches, plums, lilies, roses, columbine and ears of corn, the painting presents a true cornucopia of seasonal produce. A fig, so ripe that it has split across the middle, represents the parted lips, bunches of celery suggests the figure's full, gathered sleeves, while the breast is adorned with a garland of bursting plums.

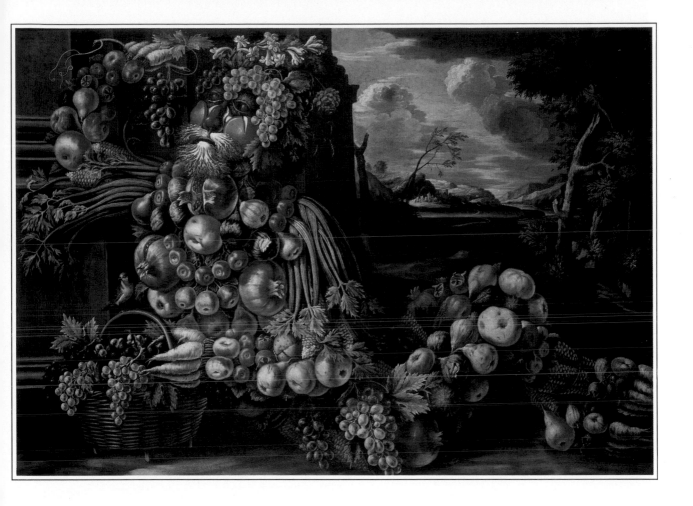

△ **Autumn** (reclining)

THIS PAINTING IS BELIEVED to be in the style of Arcimboldo, rather than being attributed to the artist himself – but the very fact that it is 'in the style of' demonstrates how great an influence Arcimboldo's stylistic ideas had in the world of art. The artist has worked all the various fruits and vegetables in fine detail; cobs of corn, grapes, bursting pomegranates and figs suggest the ripeness of autumn, rather than summer. If we look closely at this painting, we can see that the figure is fully formed: it reclines with crossed legs, raising its turnip-fingered hand to shield its sweet chestnut eyes, gazing out beyond the frame. The other hand, at the end of a celery-sleeved arm, holds a basket of grapes. In the far distance, behind the figure, is a romantic landscape, framed by autumnal trees.

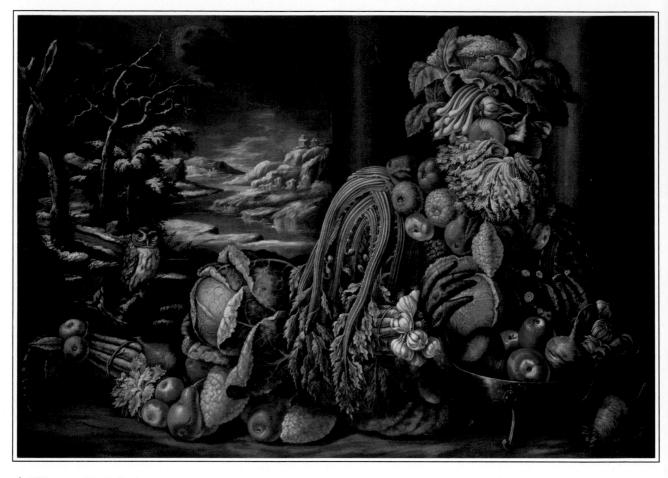

△ **Winter** (reclining)

THE FRUITFUL ABUNDANCE of *Autumn* has here withered into the dull lifelessness of *Winter*, its pictorial partner. No longer does the figure look out at the world, but draws itself inwards, lowering its cauliflower head and gazing down from under its garlic brows. The sombre mood of the painting is reinforced by its predominant greys and browns, only partly relieved by the reds of the apples and root vegetables. In the landscape outside, there is no sign of life, save for an owl, a creature of darkness and the night, perched on a branch – the trees are bare, the ground is white and frosty, and the sky is darkly ominous.

ACKNOWLEDGEMENTS

The publisher would like to thank the following for their kind permission to reproduce the paintings in this book:

Bridgeman Art Library, London/ Academia de San Fernando, Madrid: 12-13; /**Private Collection, Vienna:** 23, 28-29; /**Louvre, Paris/Lauros-Giraudon:** 33-35; /**Private Collection, Switzerland:** 42-43; /**Private Collection:** 63; /**Nostell Priory, Yorkshire:** 67; /**Ex-Edward James Foundation, Sussex:** 77-78

AKG London /**Narodni Gallery, Prague:** 8-9, photo © AKG London/Erich Lessing; /**Collection Scholss Ambras, Innsbruck:** 10-11, 65, photo © AKG London/Erich Lessing; /**Collection Braunerhylem, Djursholm:** 30-31, photo © AKG London/Erich Lessing; /**Musée du Louvre, Paris:** 33, 36-37, photo © AKG London/Erich Lessing; /**Private Collection, Paris:** 57, photo © AKG London/Erich Lessing; /**Pinacoteca Civica T. Martinengo, Brecia:** 74-76, photo © AKG London;

Kunsthistorisches Museum, Vienna: 14-18; /**National Museum, Stockholm:** 19; /**Musée du Louvre, Paris – Photo R.M.N.:** 33, 38-41; /**Photo Scala, Florence:** 44-45, 58-59; /**William A. Sargent Fund. Courtesy, Museum of Fine Arts, Boston:** 47-56; /**Skokloster Castle, 746 96, Skokloster, Sweden:** 20-22, 59-62; /**The Menil Collection, Houston:** 68; /**Ernst Reinhold-Artothek:** 69, 71; /**Blauel/Gnamm-Artothek:** 74;

Every effort has been made to trace the copyright holders and we apologise in advance for any unintentional omissions. We would be pleased to insert the appropriate acknowledgement in any subsequent edition of this publication.